DRAW **50** BABY ANIMALS

BOOKS IN THIS SERIES

DRAW 50 BABY ANIMALS

THE STEP-BY-STEP WAY TO DRAW KITTENS, LAMBS, CHICKS, AND OTHER ADORABLE OFFSPRING

Lee J. Ames

BROADWAY BOOKS

NEW YORK

BROADWAY

PRINTED IN THE UNITED STATES OF AMERICA

BROADWAY BOOKS and its logo, a letter B bisected on the diagonal, are trademarks of Broadway Books, a division of Random House, Inc.

Visit our website at www.broadwaybooks.com

First edition published 2003

Library of Congress Cataloging-in-Publication Data
Ames, Lee J.
 Draw 50 baby animals : the step-by-step way to draw kittens, lambs, chicks, and other adorable offspring / by Lee J. Ames.—1st ed.
 p. cm.
 Summary: Step-by-step instructions for drawing fifty baby animals.
 1. Animals in art—Juvenile literature. 2. Drawing—Technique—Juvenile literature.
 [1. Animals in art. 2. Drawing—Technique.] I. Title: Draw fifty baby animals. II. Title.
 NC780 .A4813 2003
 743.6—dc21 2002033247

ISBN 0-7679-1283-7 (HC)
ISBN 0-7679-1284-5 (TP)

10 9 8 7 6 5 4 3 2 1

In loving memory of Kenneth Zak, wonderful husband, father and son, brother, and great friend.

His warm smile, tender heart, and great sense of humor are sorely missed . . . he is forever in our hearts.

Author's Note

In 1962, when I was an artist-in-residence at Doubleday, my editor, Bill Hall, asked me to write a book. "I draw, illustrate, paint. I can't write," said I. "We're out of art projects for you to work on, so, for you to work here, write!" said Bill. "Okay!" I said, and in a few months I managed to create a little book called *Draw, Draw, Draw!* To my surprise, it did well. That started it all . . .

As a result, twenty-nine years ago we published *Draw 50 Animals*, the first in this series, and now we offer you what is likely to be the last, *Draw 50 Baby Animals*.

We are grateful to all of you who have made these books very popular. Among the many rewards we have enjoyed, perhaps the most meaningful was hearing from many librarians that the Draw 50s had been responsible for bringing many young people who otherwise might not have done so into using the library and its books.

As for the coauthors with whom I've worked, each in his or her own right is or was a most highly esteemed professional! For having had the privilege of working with P. Lee Ames, Warren Budd, the late Ray Burns, Anthony D'Adamo, Ric Estrada, Mort Drucker (the 1988 recipient of the Rubin, the highest award granted to a member of the National Cartoonists Society), Creig Flessel (awarded the meritorious Silver T-Square by the National Cartoonists Society), my late very close friend Andre Leblanc (recipient of the Cruzeiro do Sul [The Southern Cross], the most prestigious award granted to a Brazilian citizen), and Bob Singer, I am most indebted.

It has also been a privilege to be associated contemporarily with some other excellent how-to author/illustrators such as Mark Kistler, Ed Emberly, Doug Dubosque, and Bruce Blitz.

<div align="right">

LEE J. AMES, BTG

</div>

How To

Some tips on how to use and enjoy using this book:

Please treat the subjects tenderly and very lovingly! They are all very young.

When you start working, use clean white bond paper or drawing paper and a pencil with moderately soft lead (HB or No. 2). Have a kneaded eraser on hand (available at art-supply stores). Choose any one of the subjects in the book that you want to draw, and then very lightly and very carefully sketch out the first step. As you do so, study the finished step of your chosen drawing to sense how your first step will fit in. Make sure that the size of the first step is not so small that the final drawing will be tiny, or so large that you won't be able to fit the finish on the paper. Then, also very lightly and very carefully, sketch out the second step. As you go along, step by step, study not only the lines but also the size of the spaces between the lines. Remember, the first steps must be constructed with the greatest care. A wrongly placed stroke could throw the whole drawing off!

As you work, it is a good idea to have a mirror available. Holding your sketch up to the mirror from time to time can show you distortions you might not see otherwise.

As you are adding the steps, you may discover that they are becoming too dark. Here's where the kneaded eraser becomes particularly useful. You can lighten the darker penciling by just strongly pressing the clay-like eraser onto the dark areas.

When you've put it all together and gotten to the last step, finish the drawing firmly with dark, accurate strokes. There is your finished drawing. However, if you want to further finish the drawing with India ink, applied with a pen or fine brush, after the ink completely dries you can clean out all of the penciling with the kneaded eraser.

Remember, if your first attempts do not turn out too well, it's important to keep trying. Practicing and patience do indeed help. I would like you to know that on occasion when I have used the steps for a drawing from one of my own books, it has taken me as much as an hour or two to bring it to a finish.

I hope you enjoy drawing these baby animals. Remember, they are babies—handle them gently.

DRAW 50 BABY ANIMALS

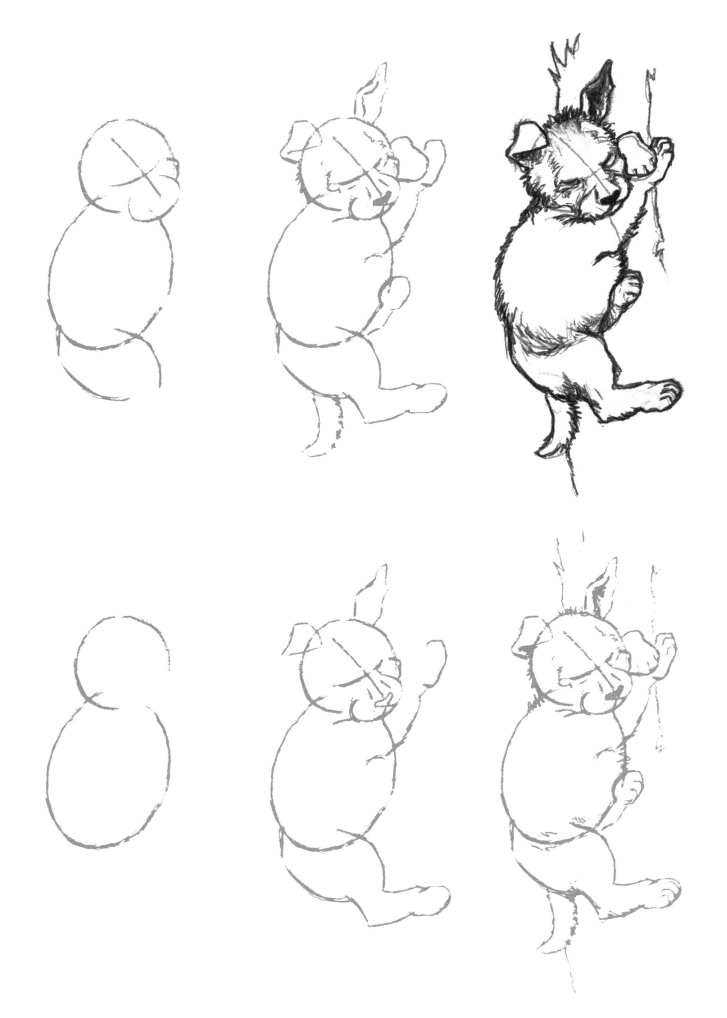

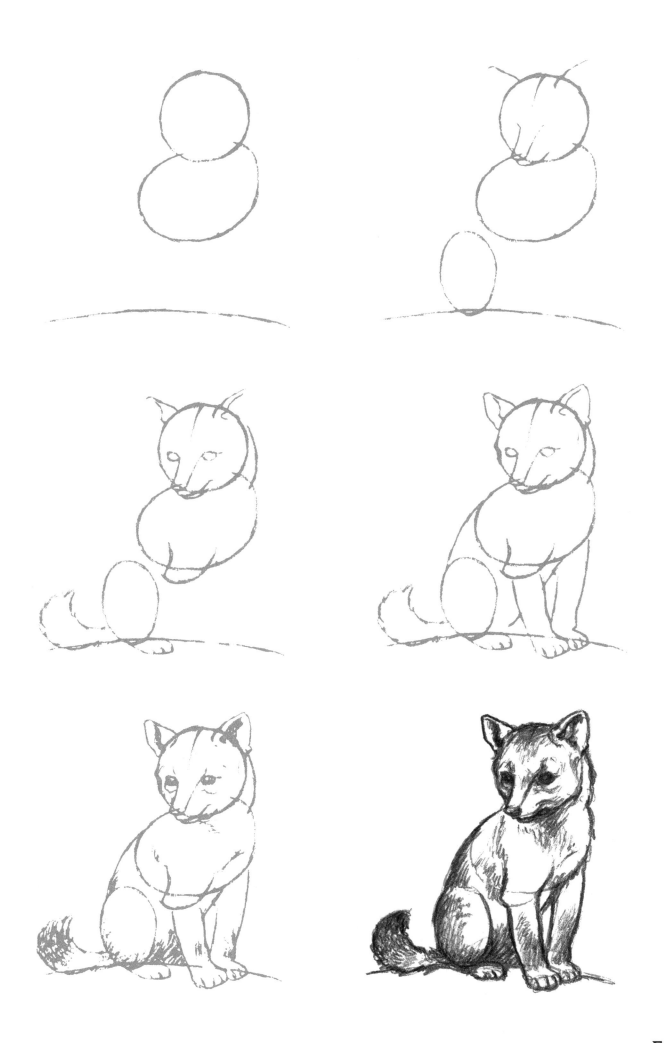

FOX Kit

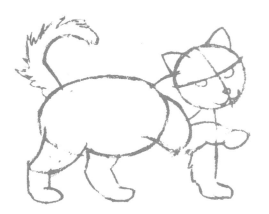
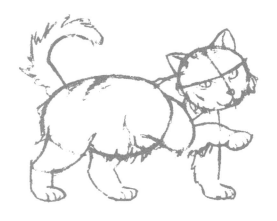
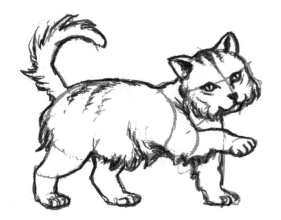

CAT Kitten

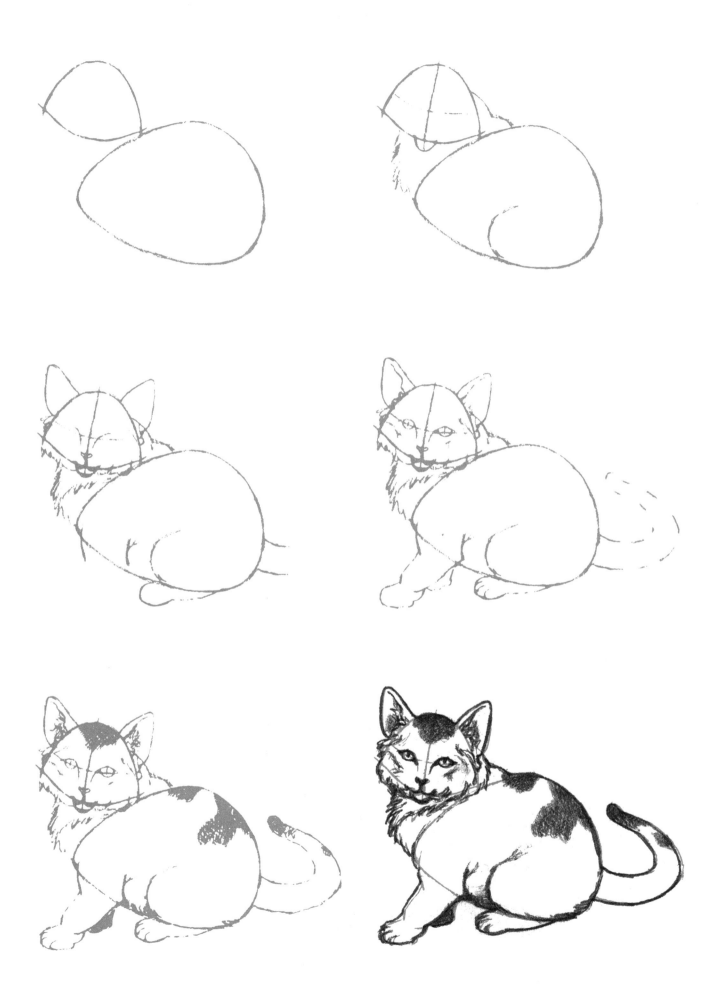

CAT Kitten

LION Cub

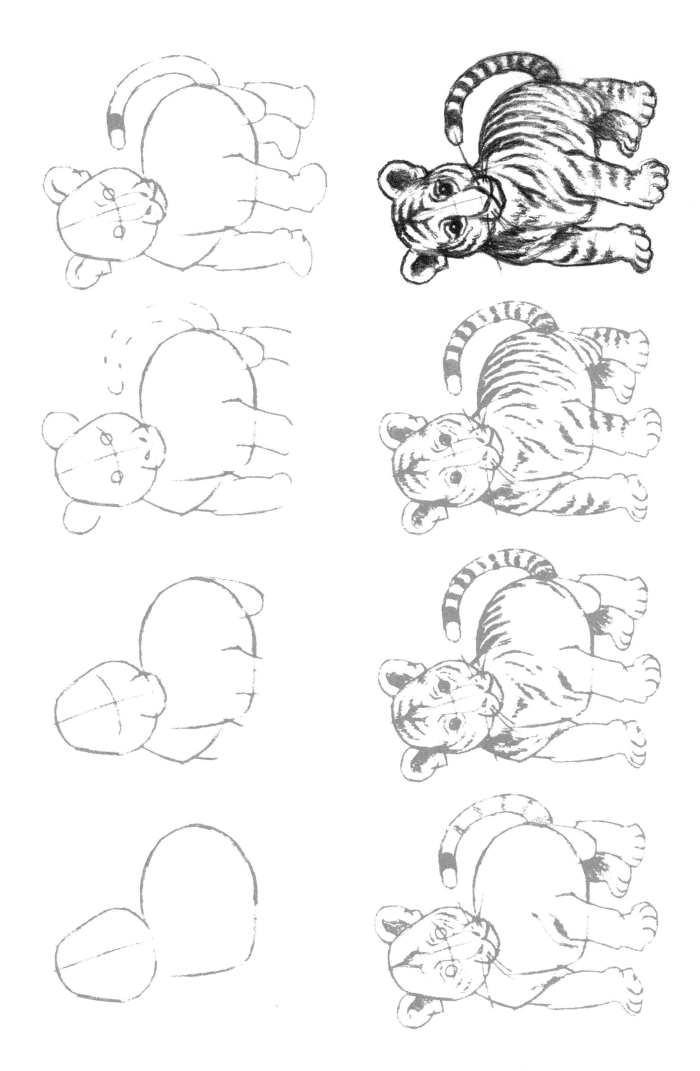

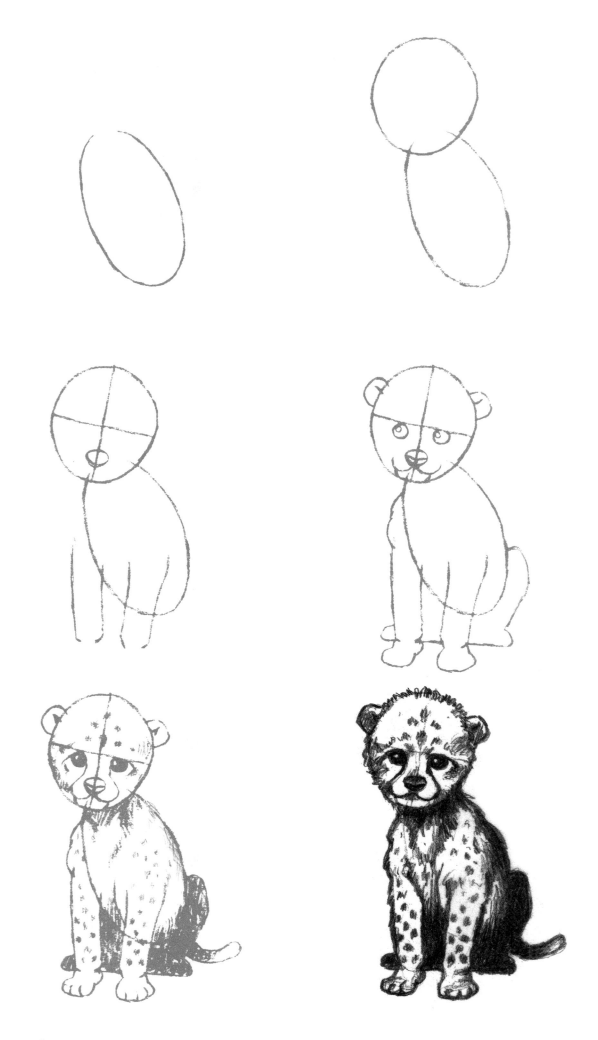

CHEETAH Cub

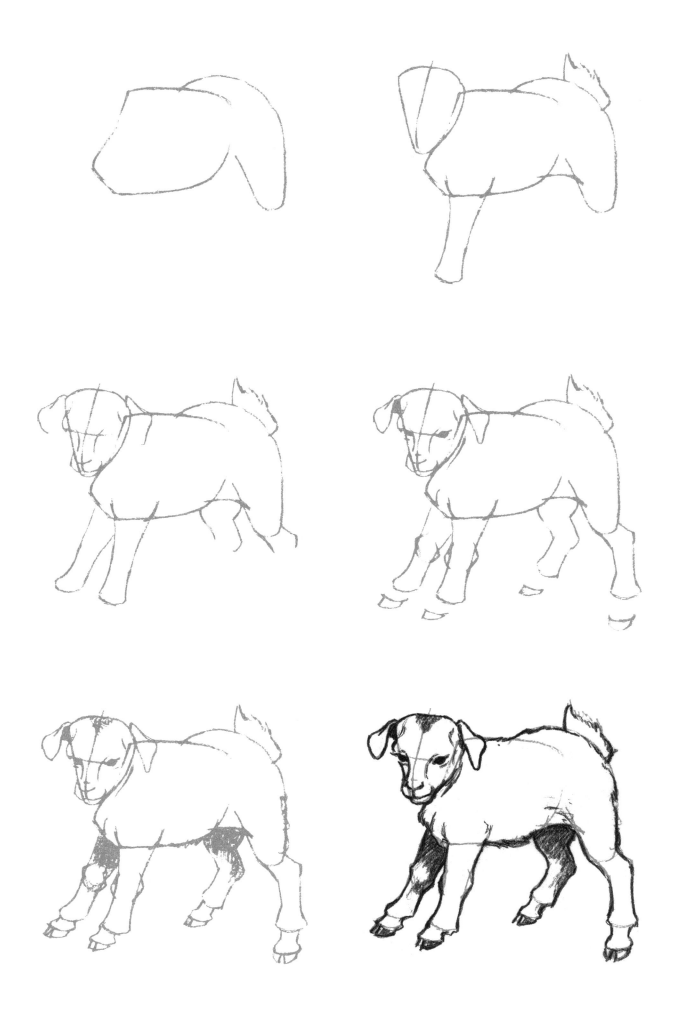

GOAT Kid

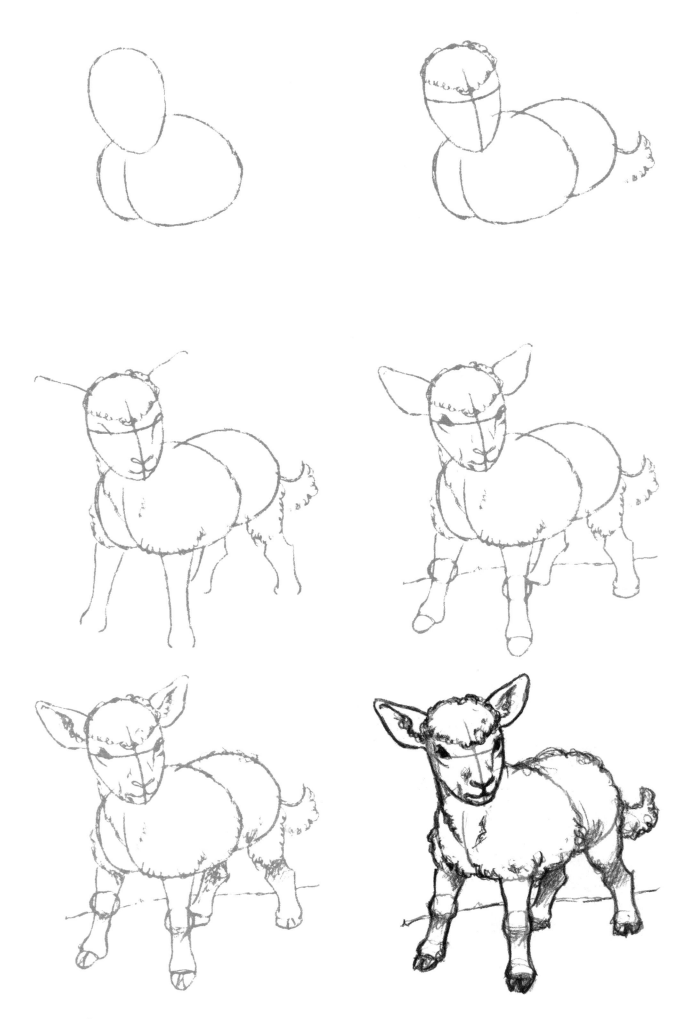

SHEEP Lamb

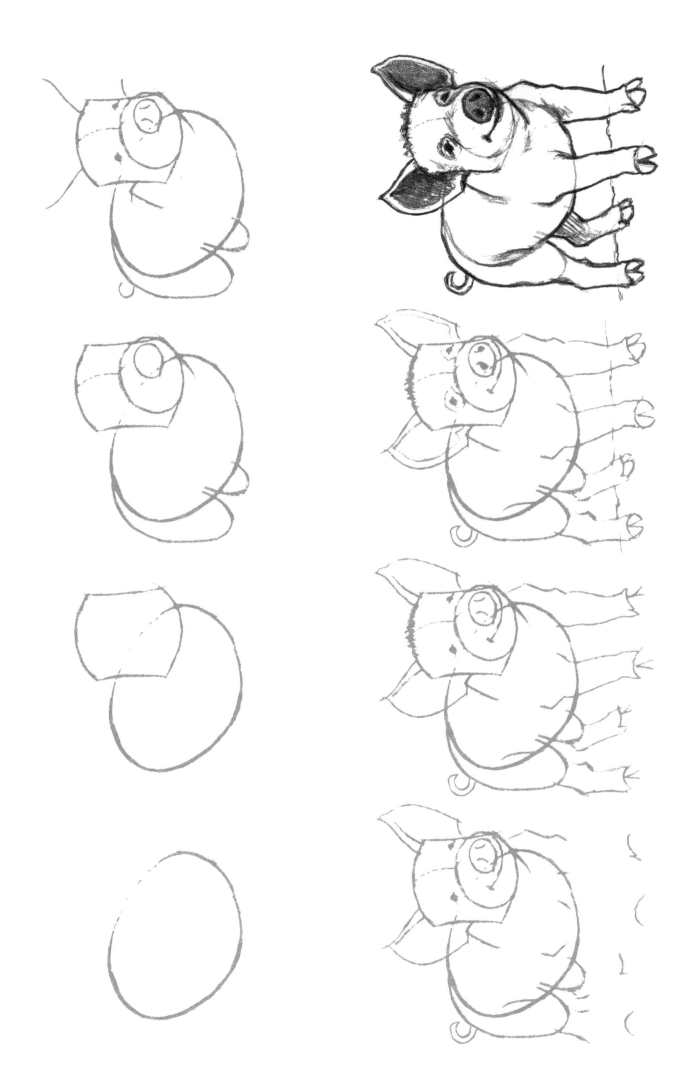

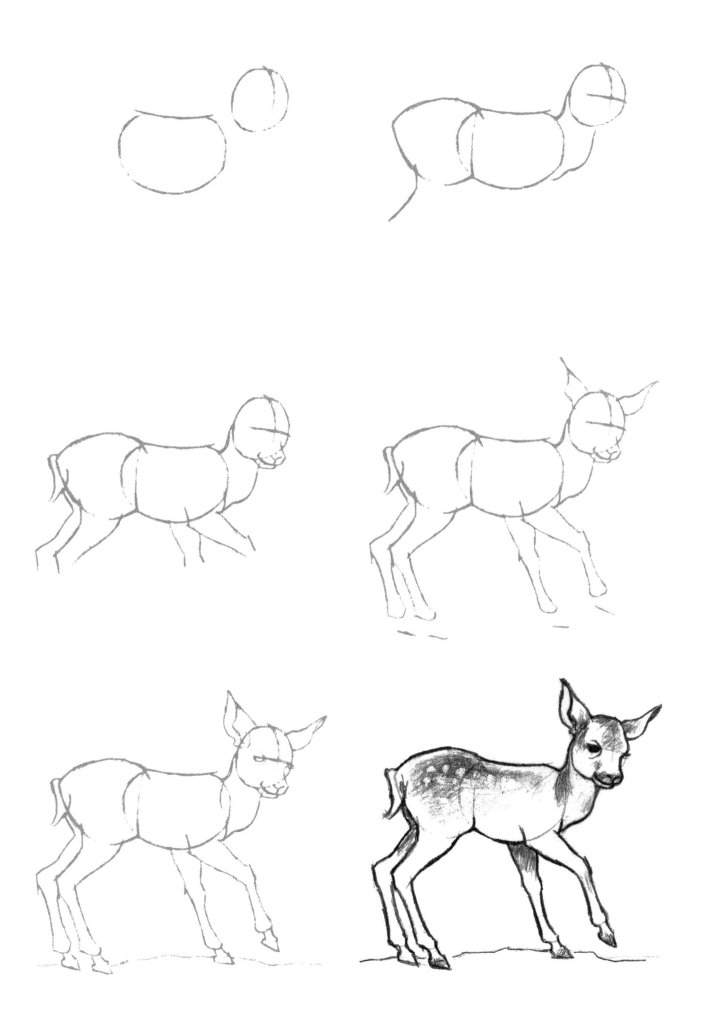

DEER Fawn

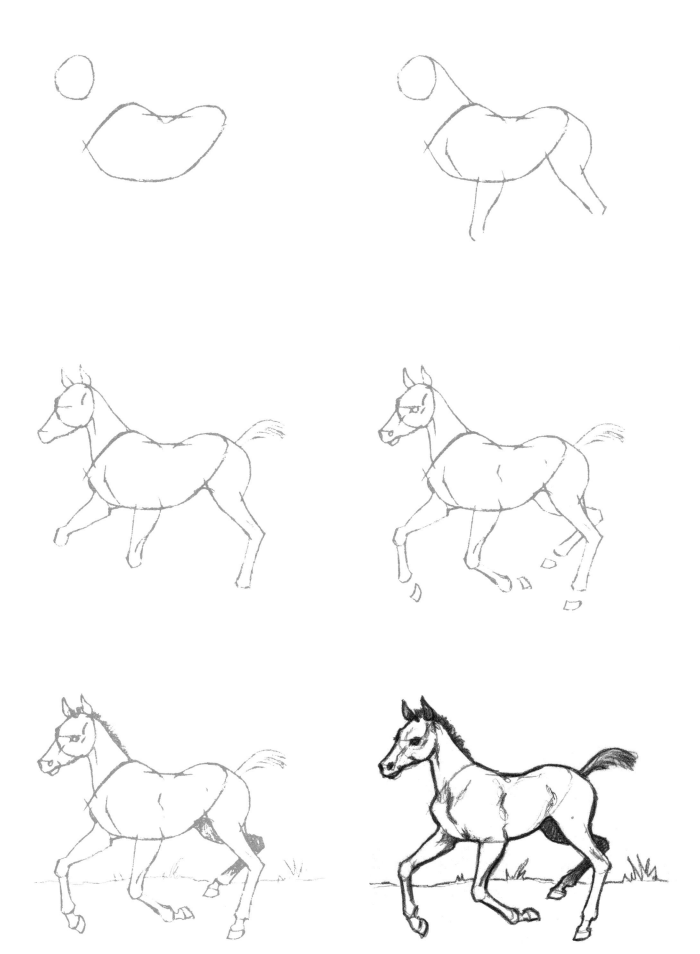

HORSE Foal

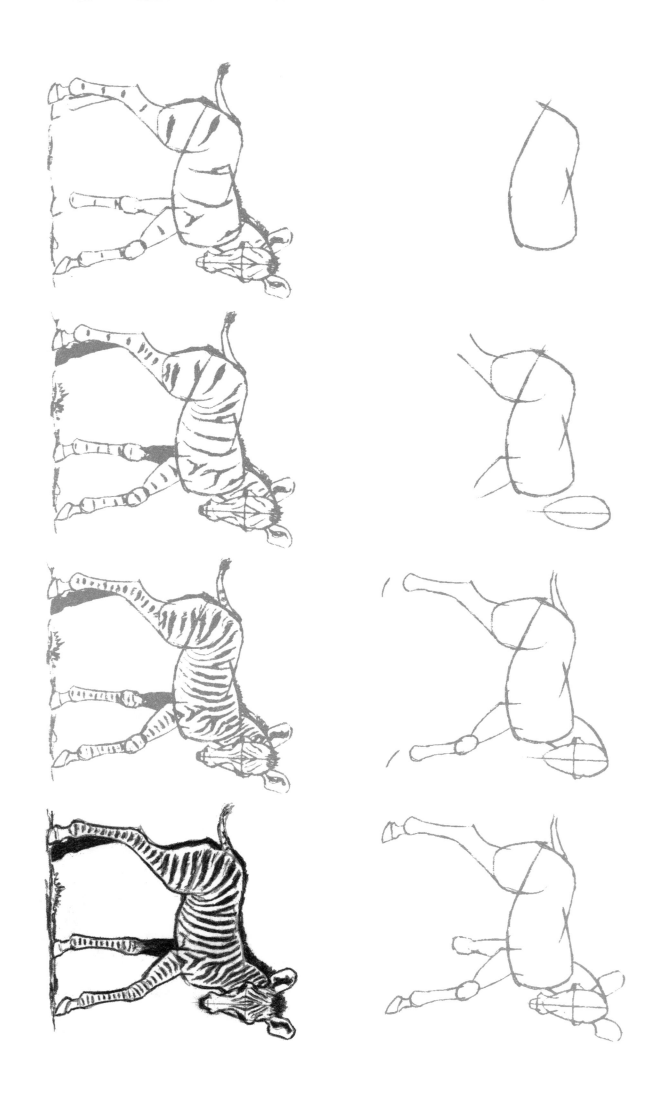

ZEBRA Foal

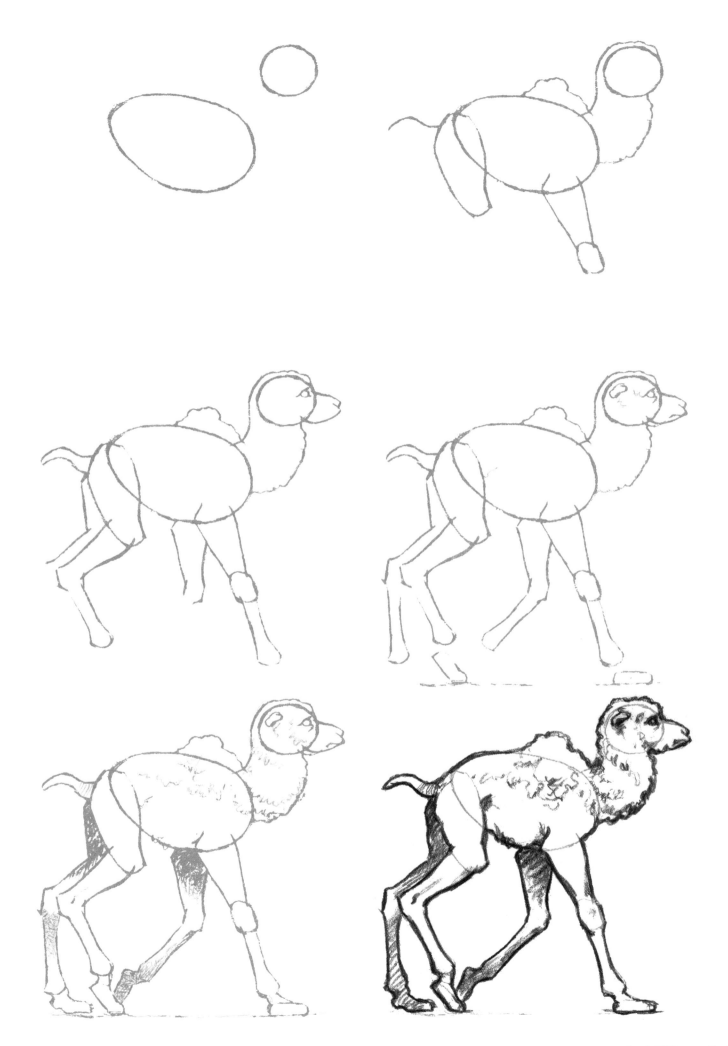

CAMEL Calf

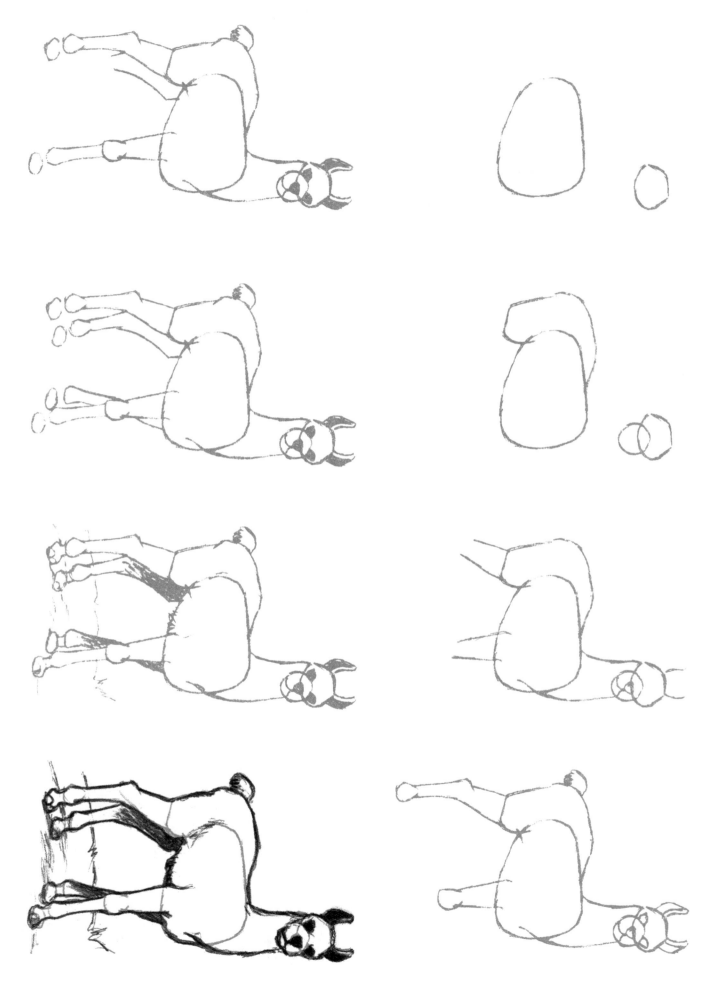

LLAMA Cria

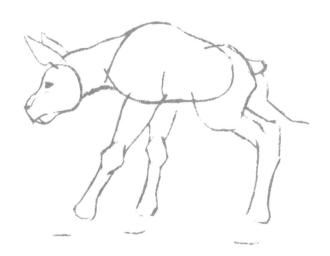
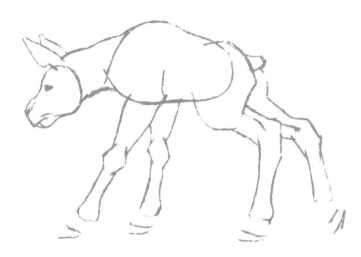
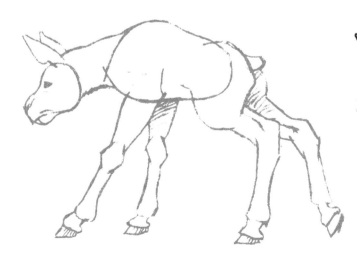
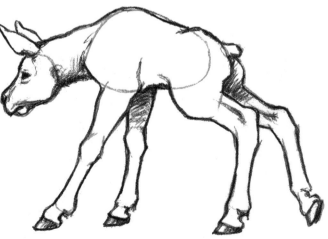

MOOSE Calf

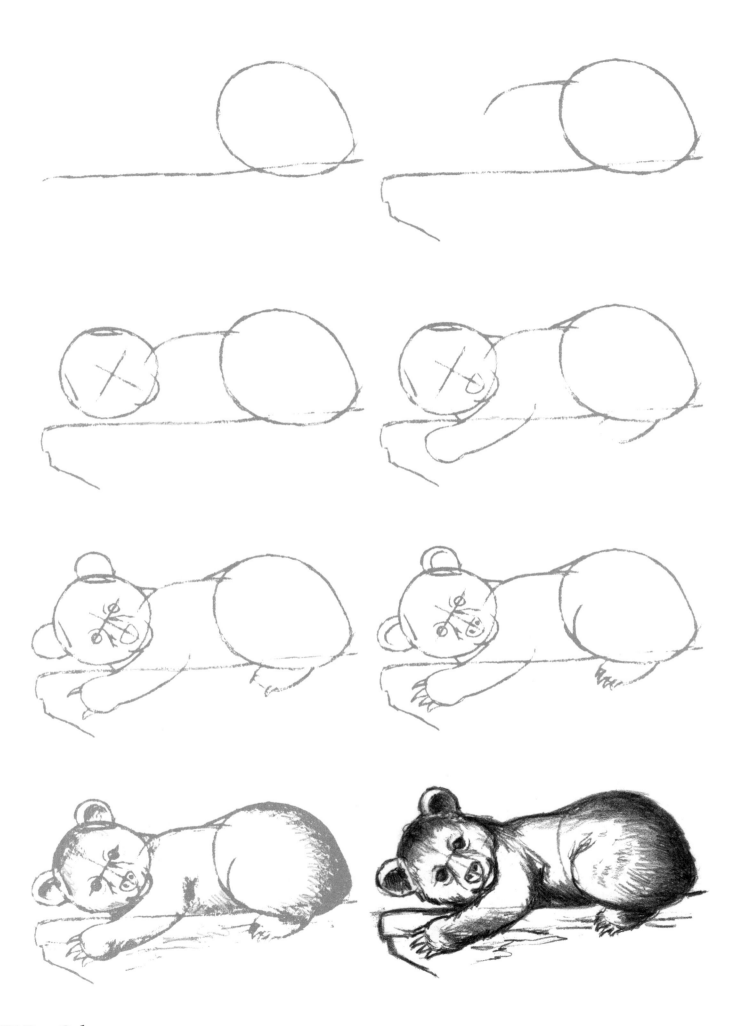

BEAR Cub

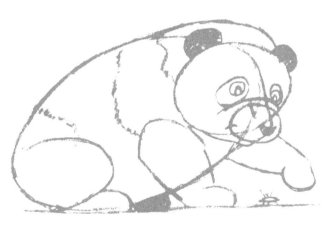
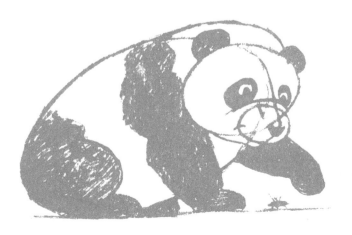
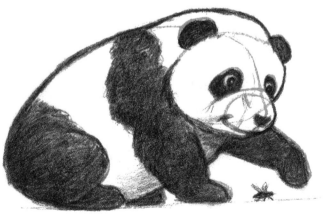

PANDA Cub

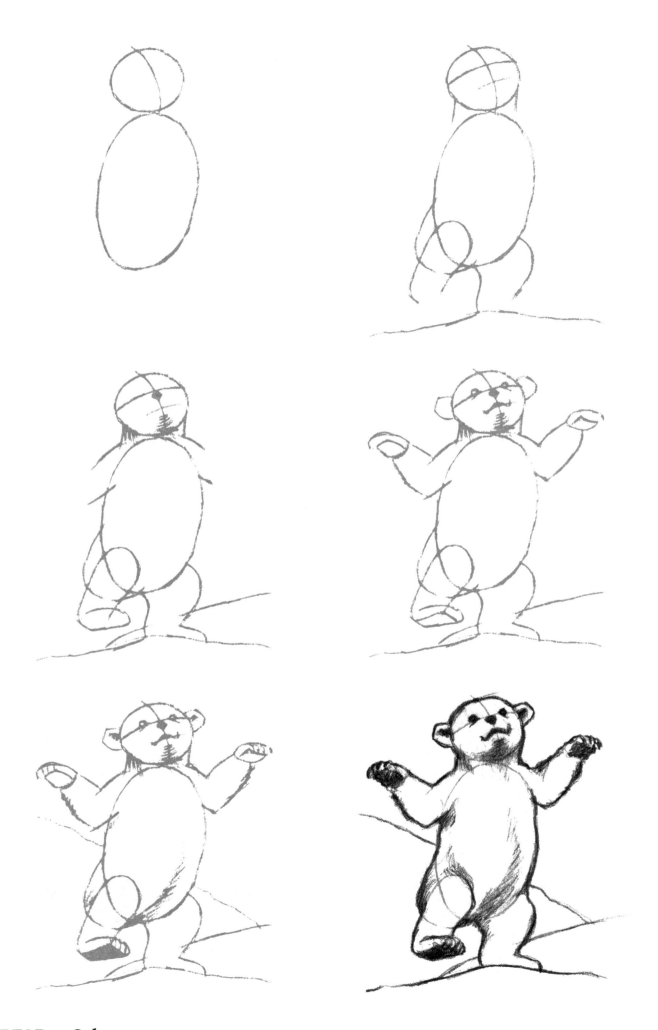

POLAR BEAR Cub

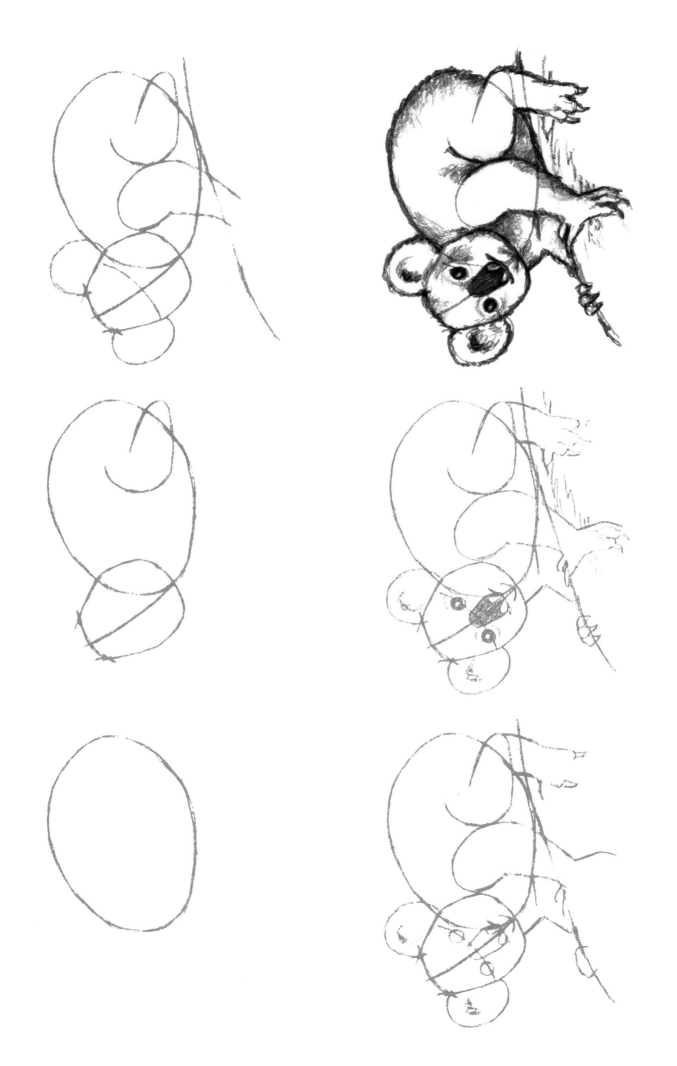

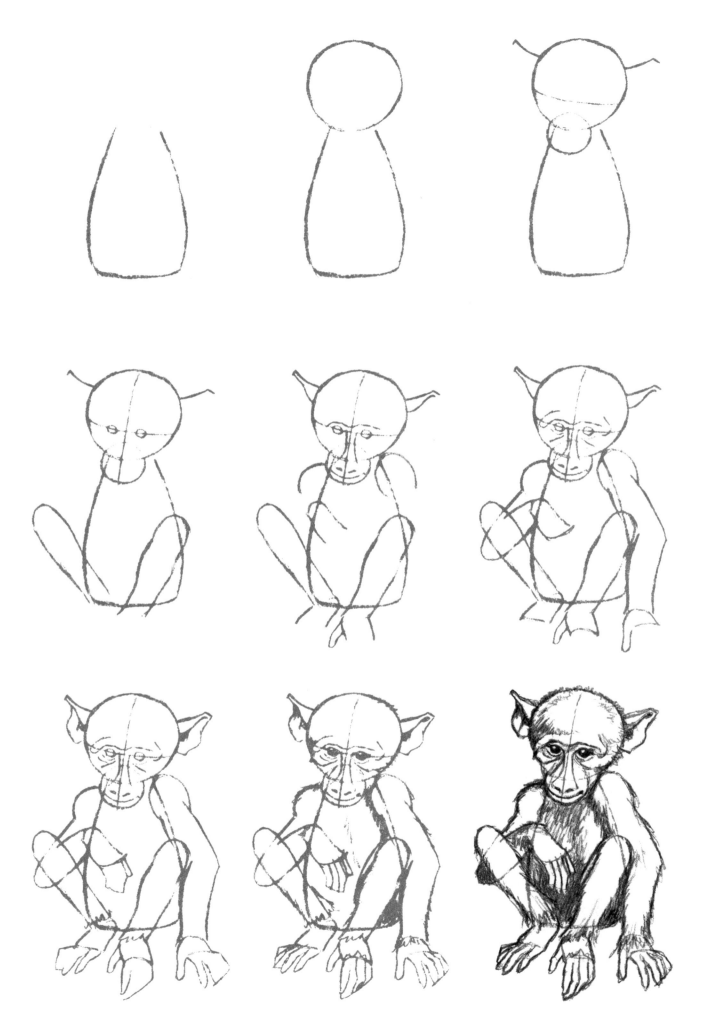

BABOON Infant

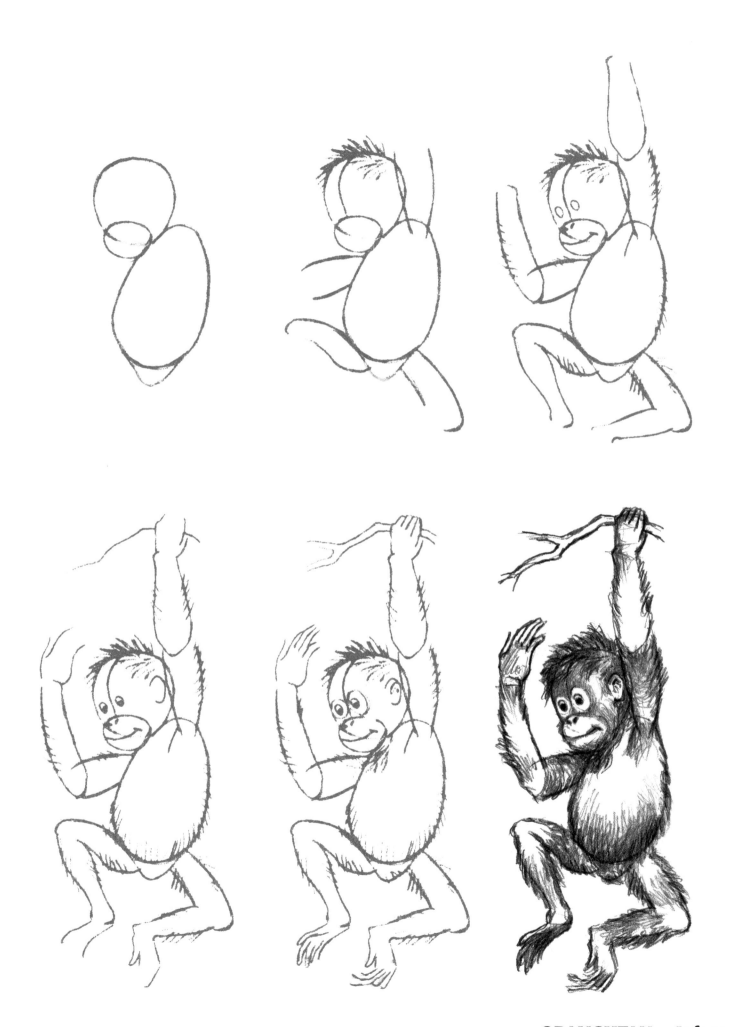

ORANGUTAN Infant

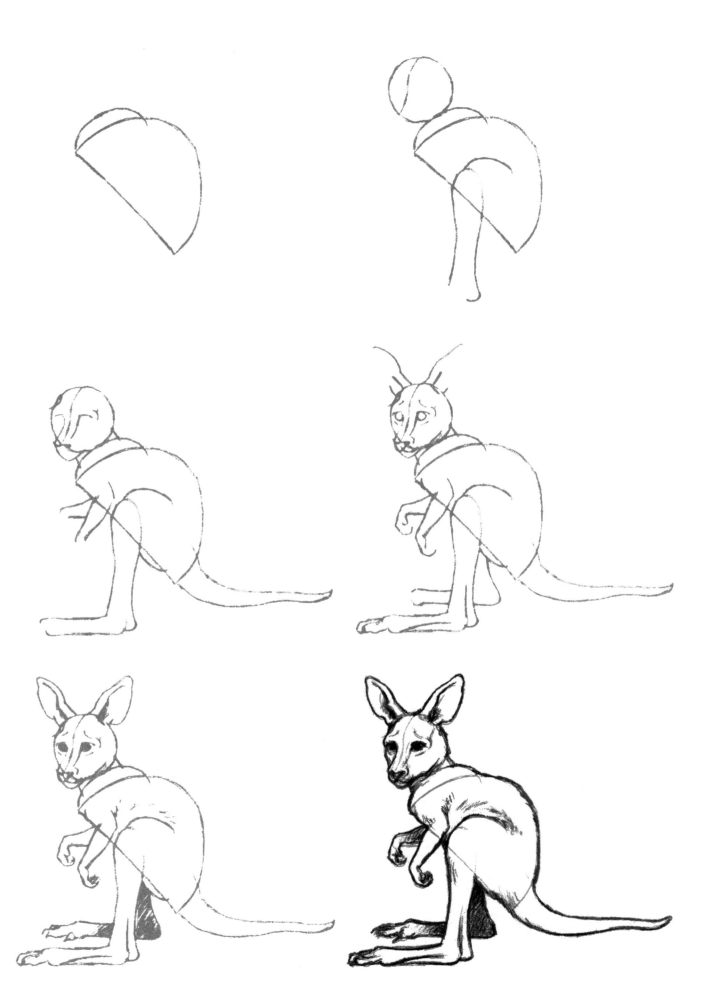

KANGAROO Joey

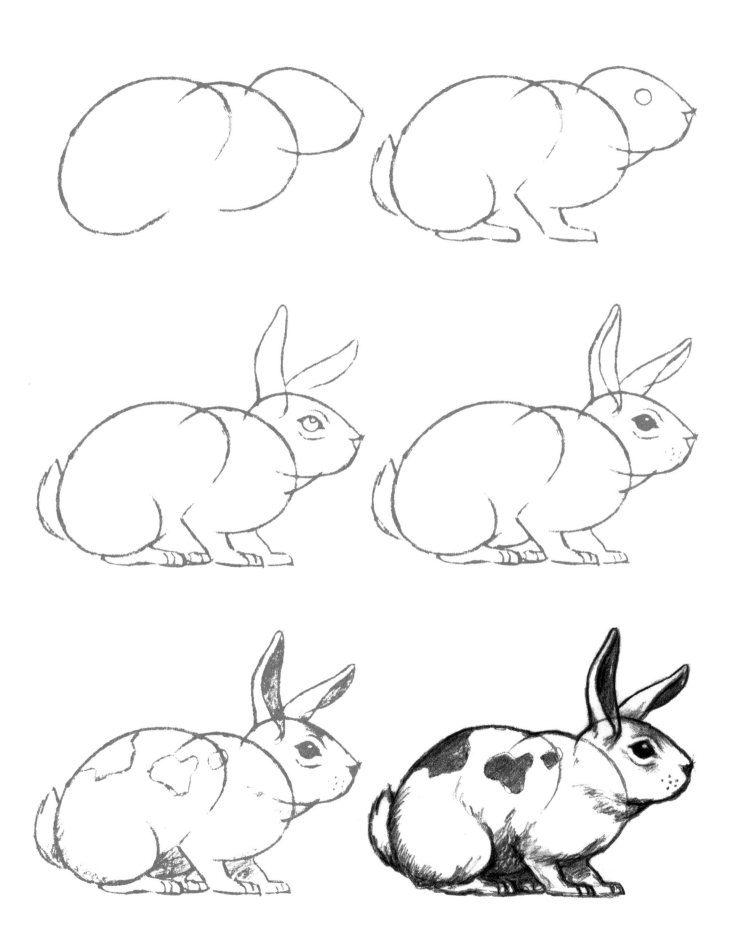

RABBIT Bunny

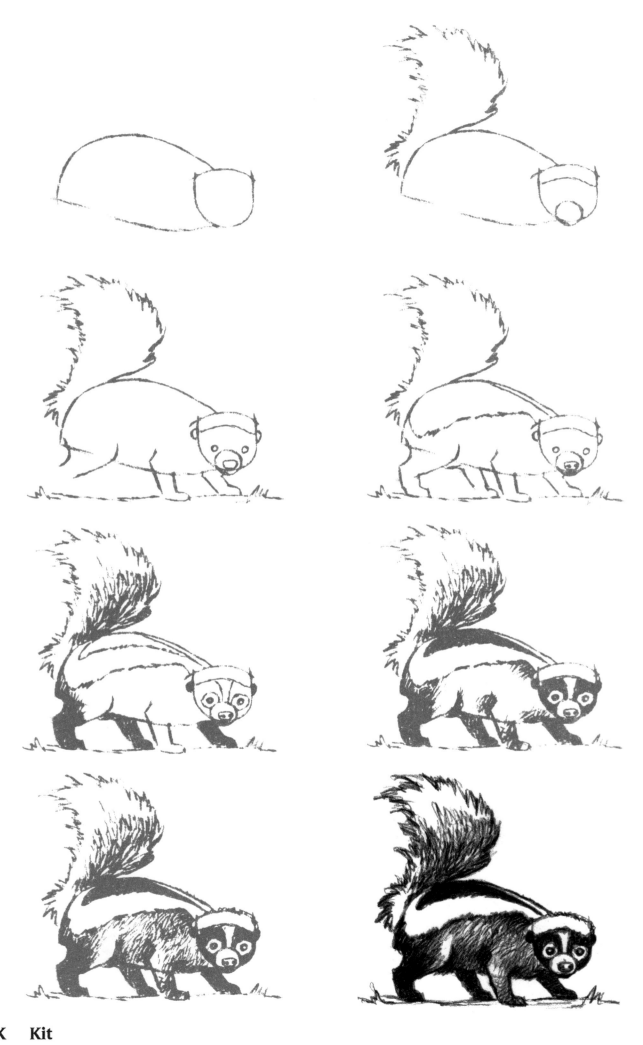

SKUNK Kit

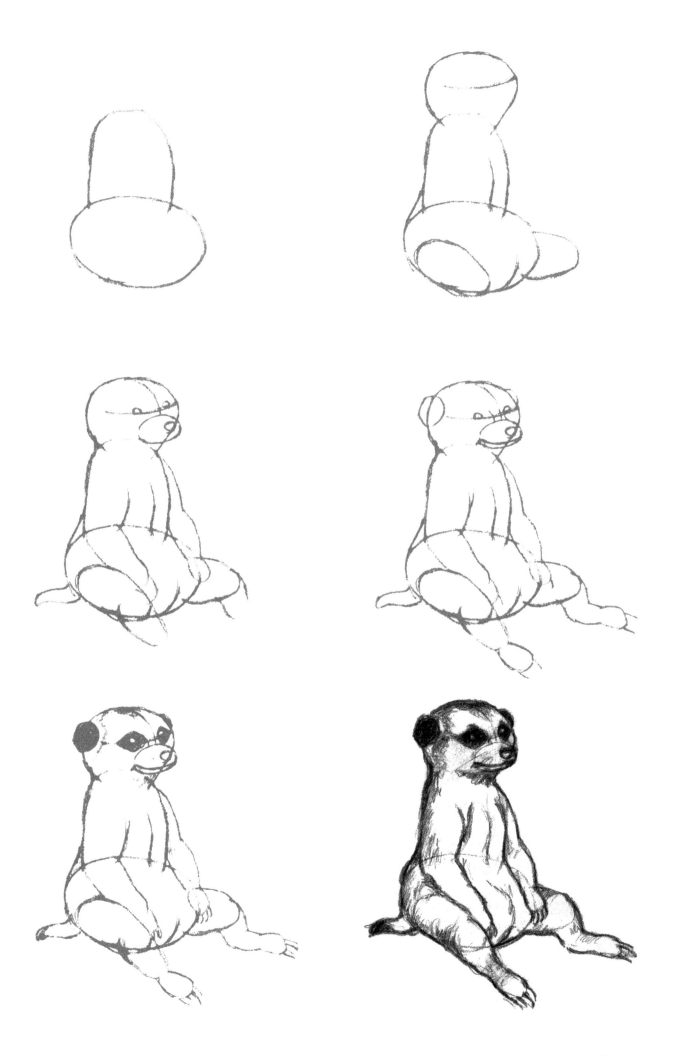

MEERKAT Pup

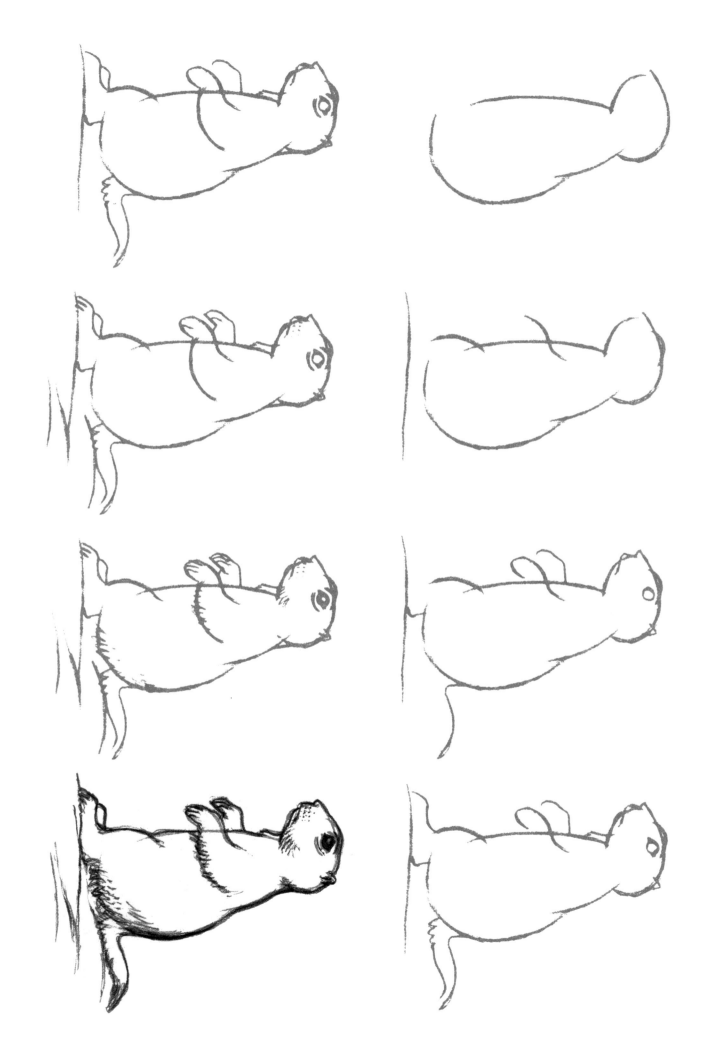

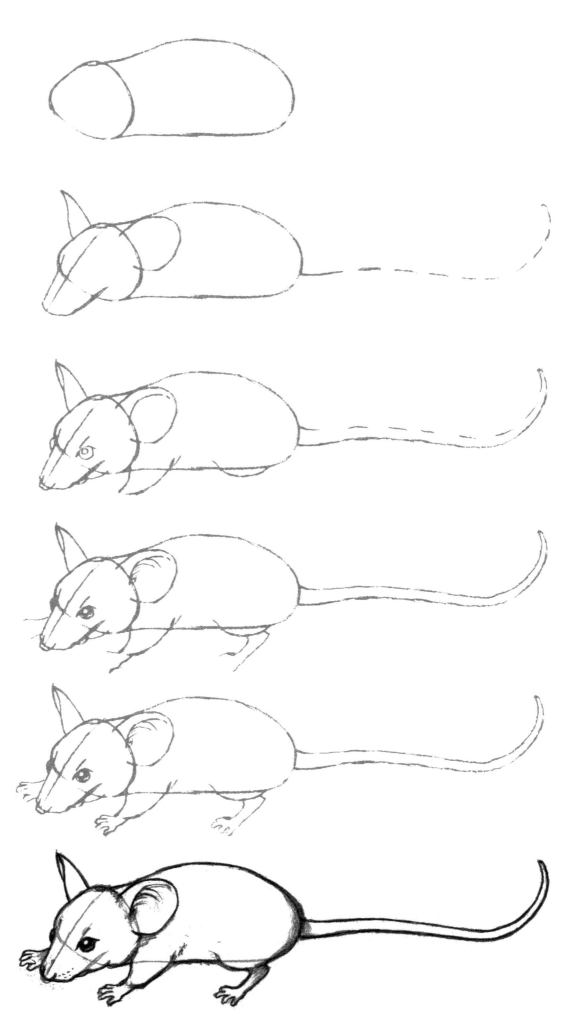

MOUSE Pinkie

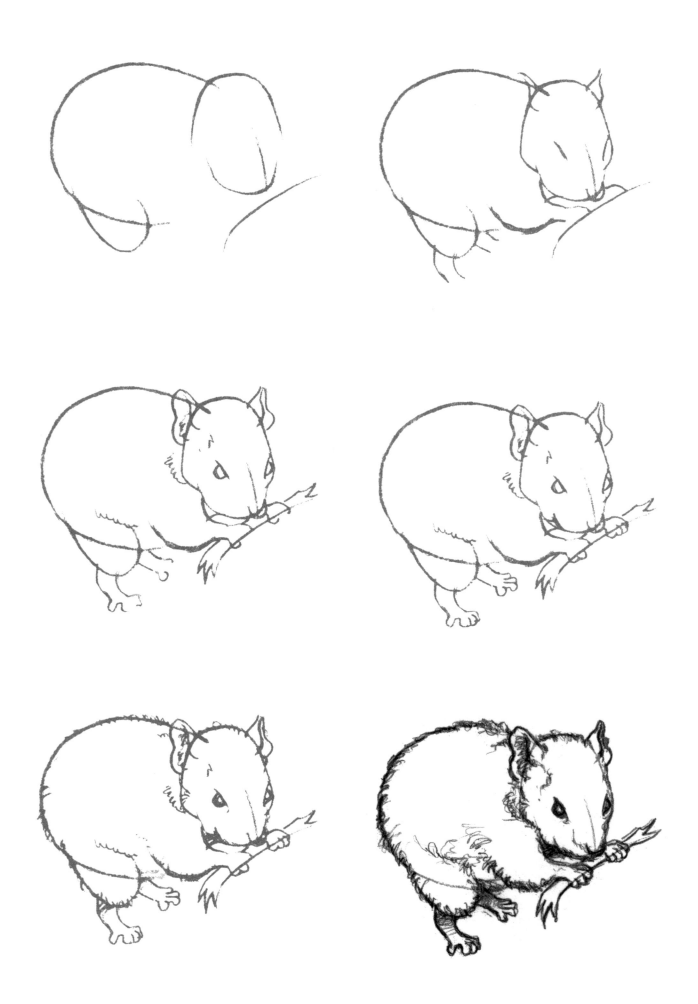

HAMSTER Pup

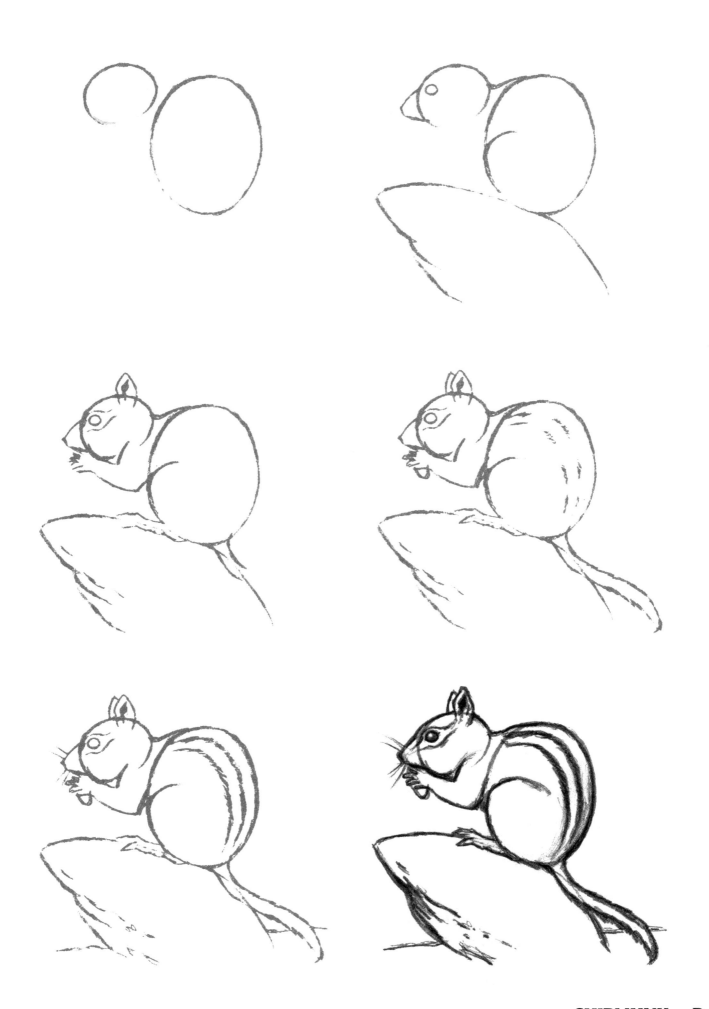

CHIPMUNK Pup

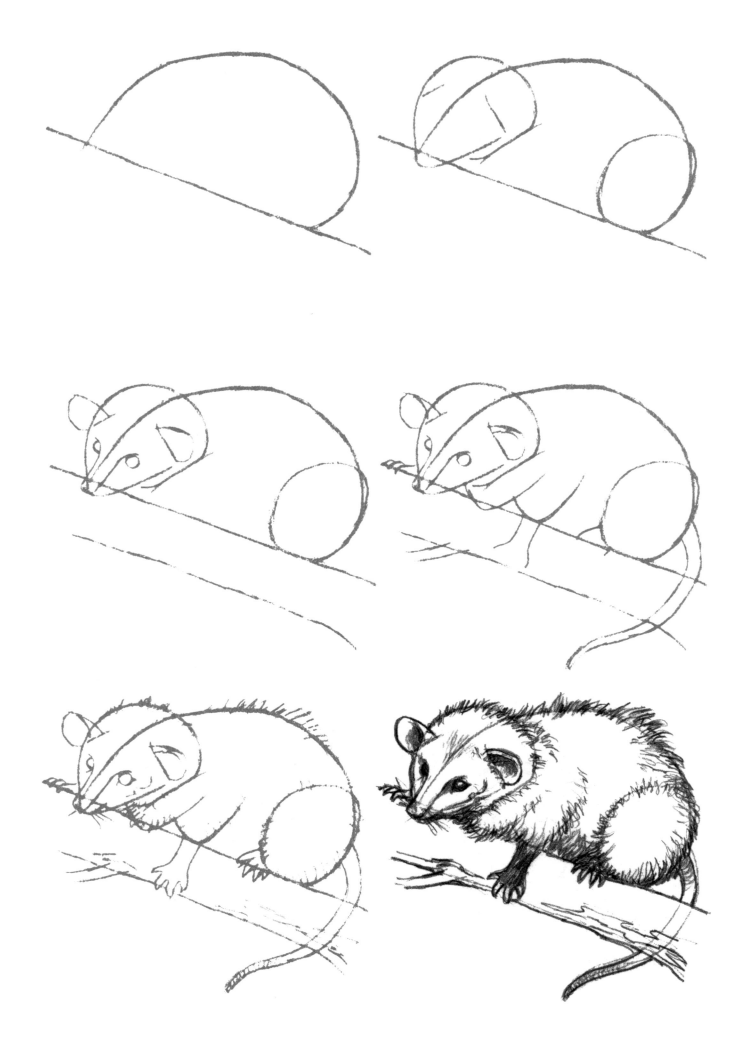

OPOSSUM Joey

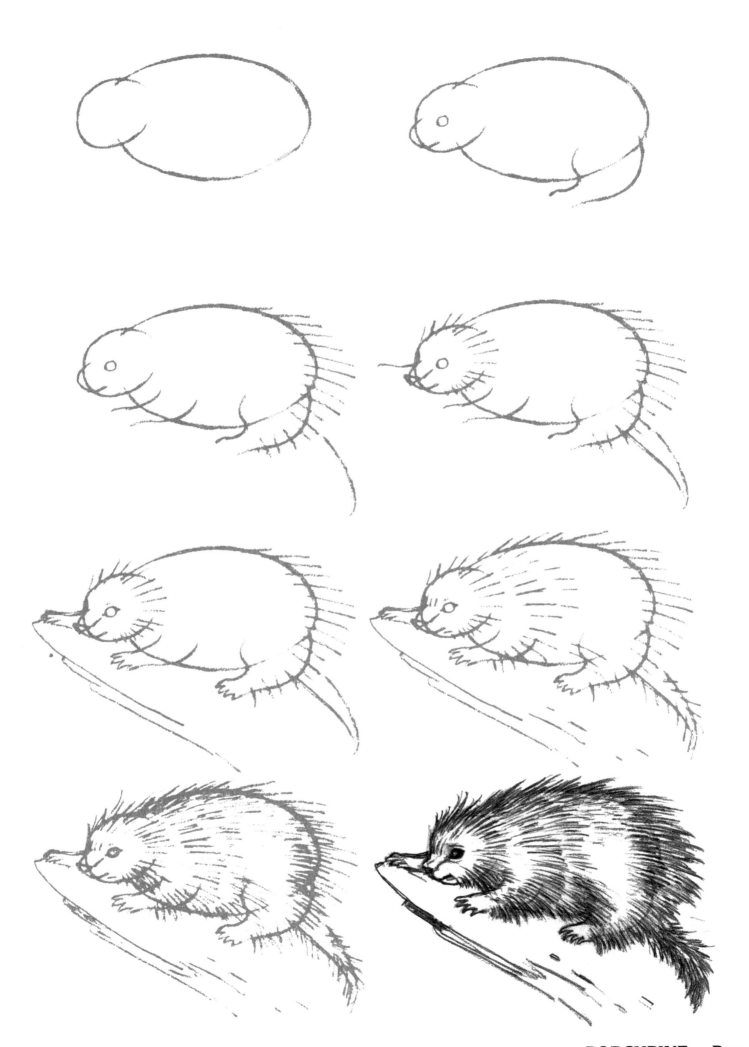

PORCUPINE Pup

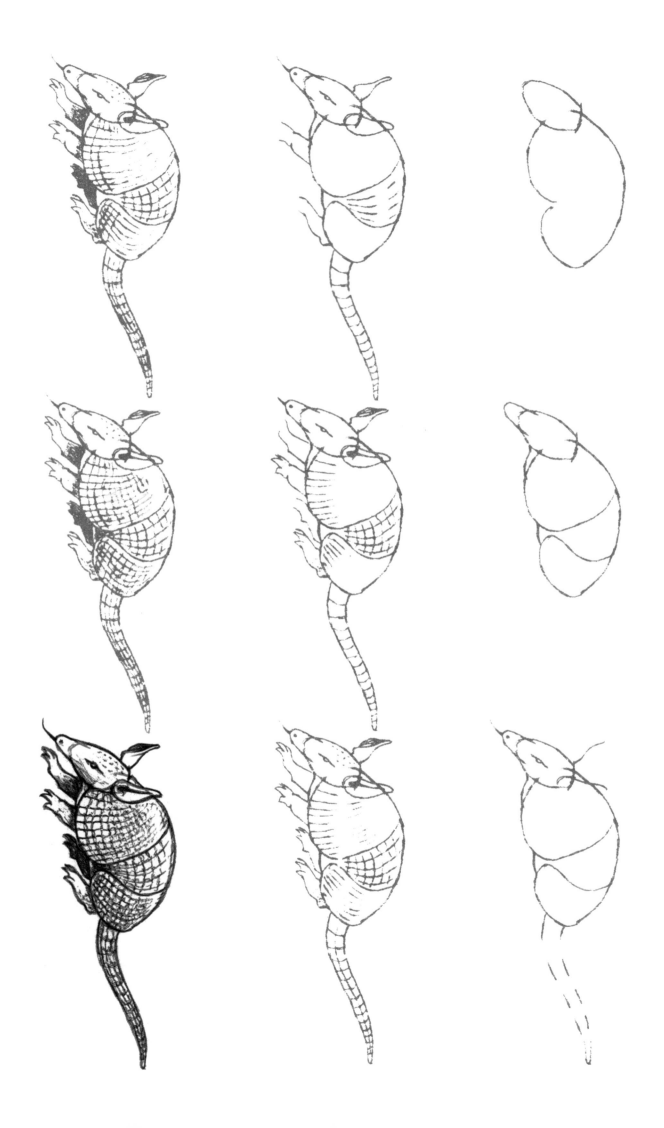

ARMADILLO Pup

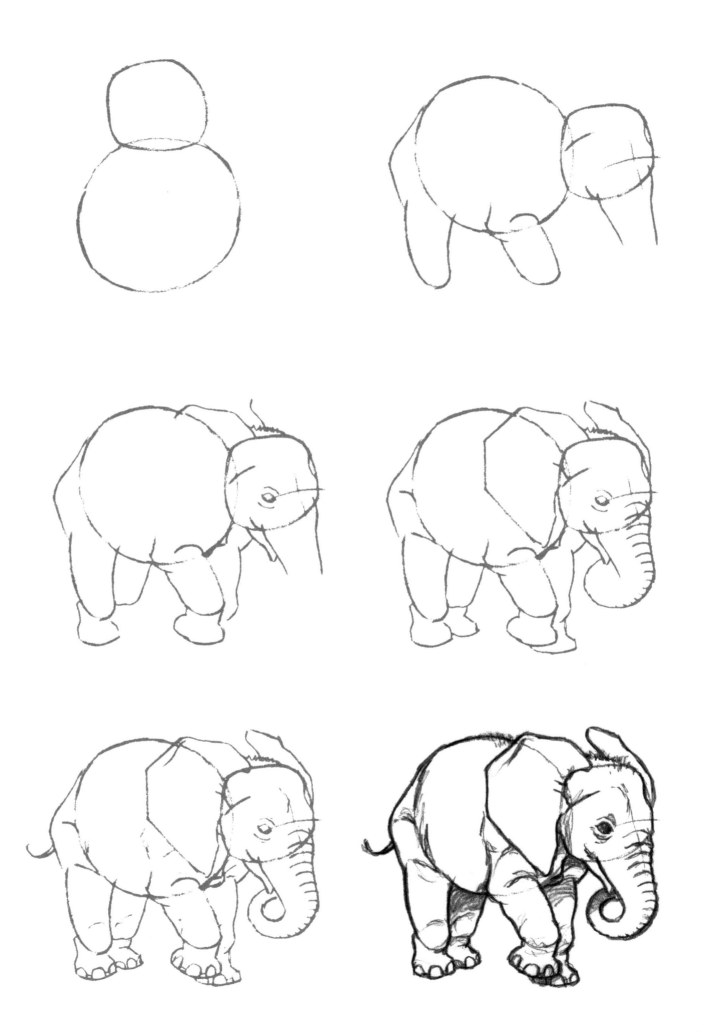

ELEPHANT Calf

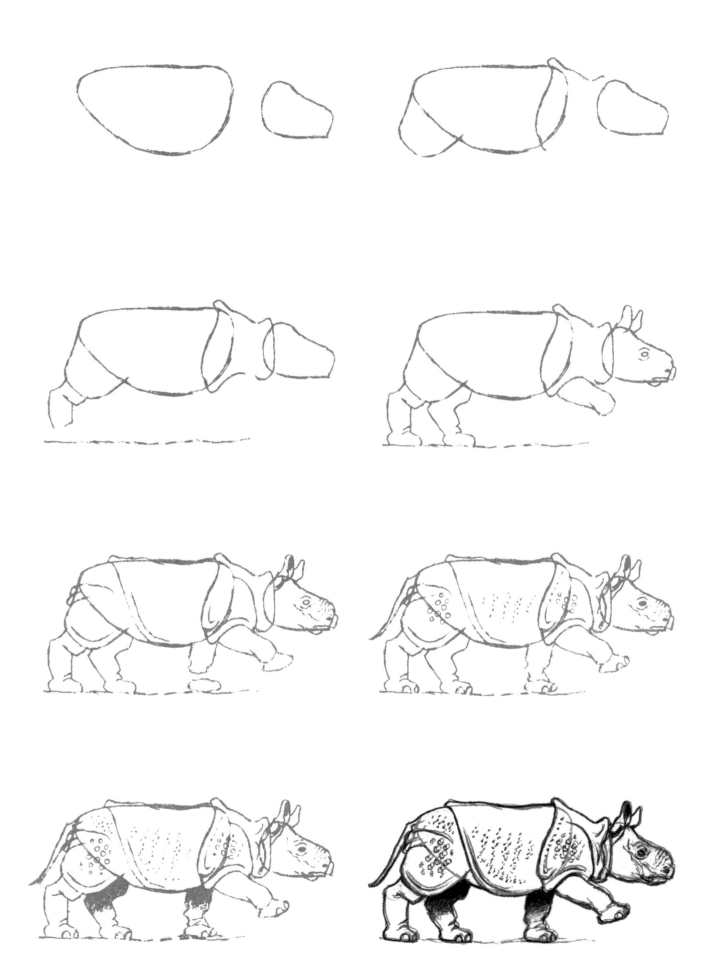

RHINOCEROS Calf

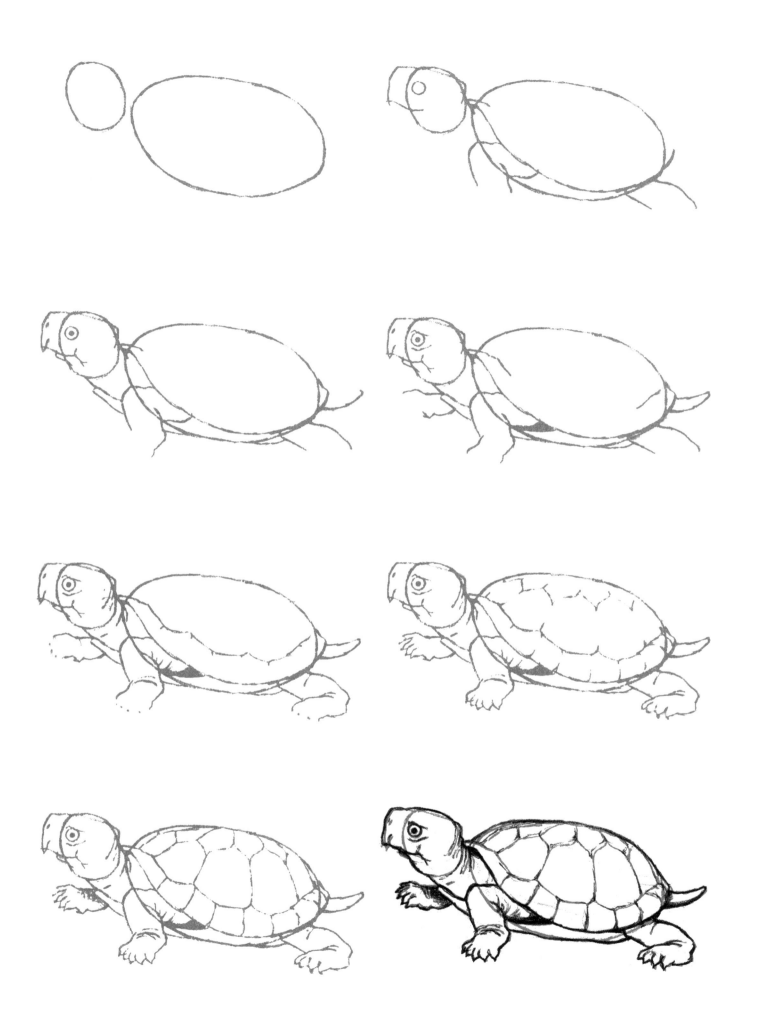

TURTLE Hatchling

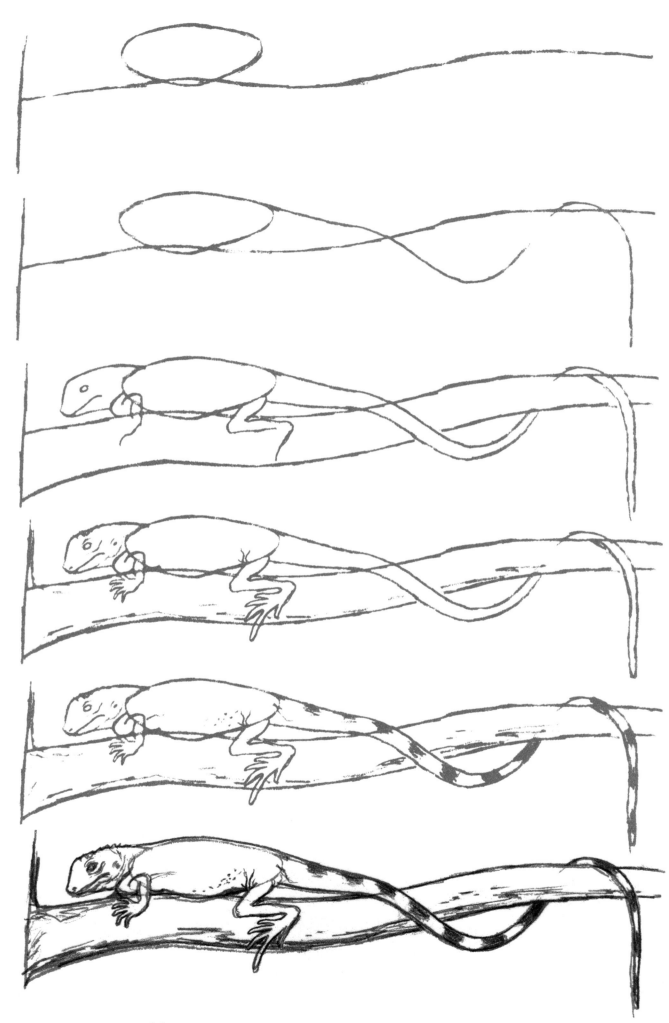

GREEN IGUANA **Hatchling**

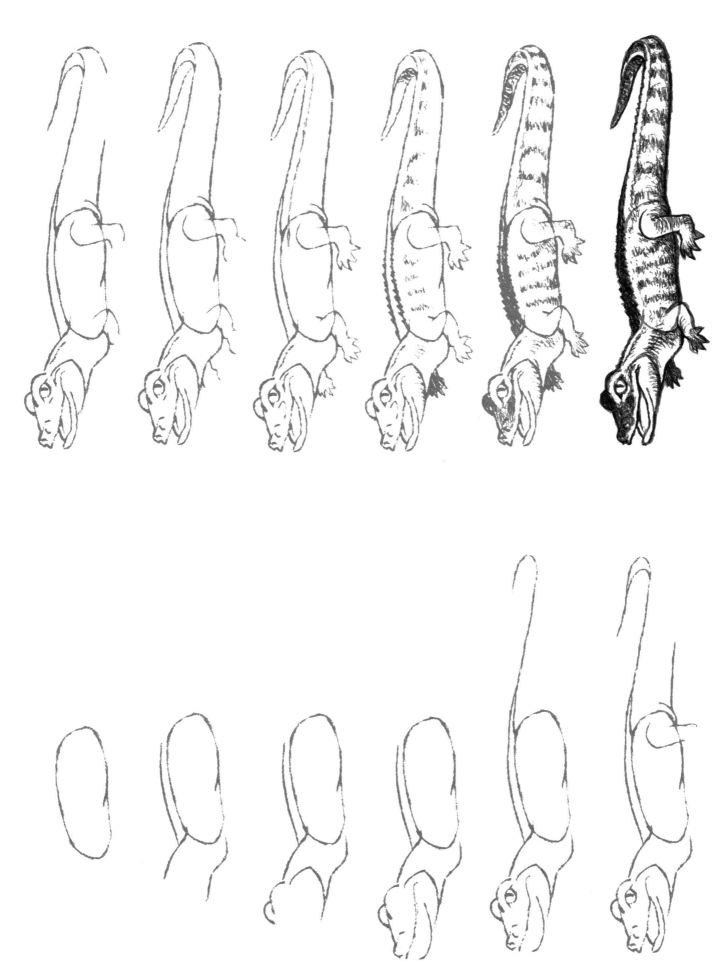

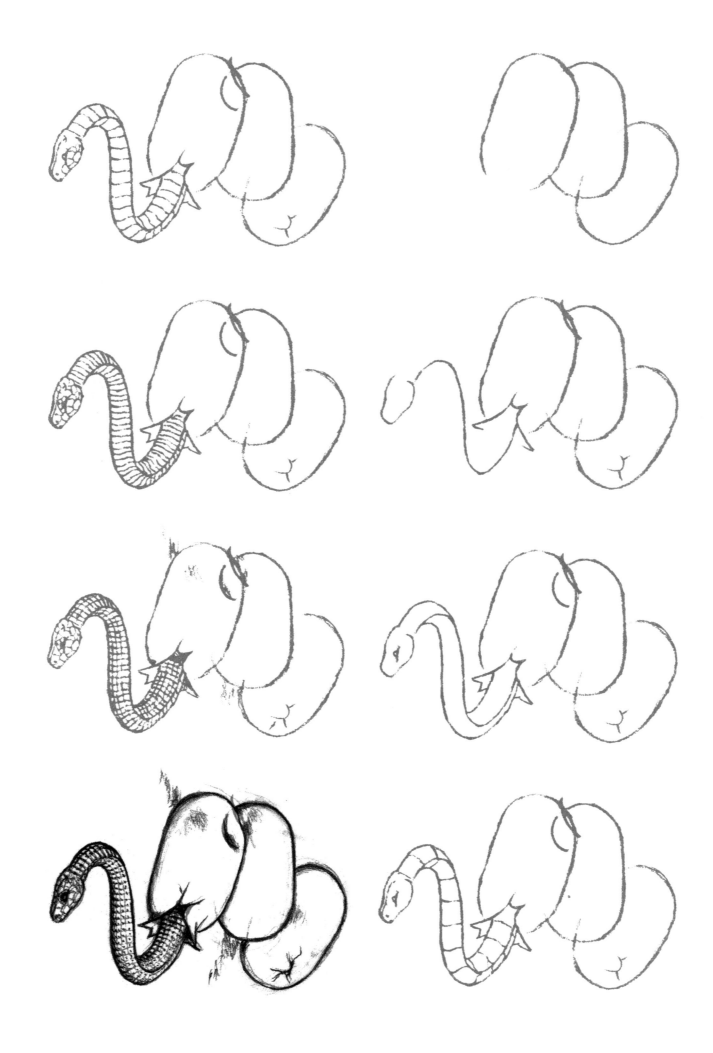

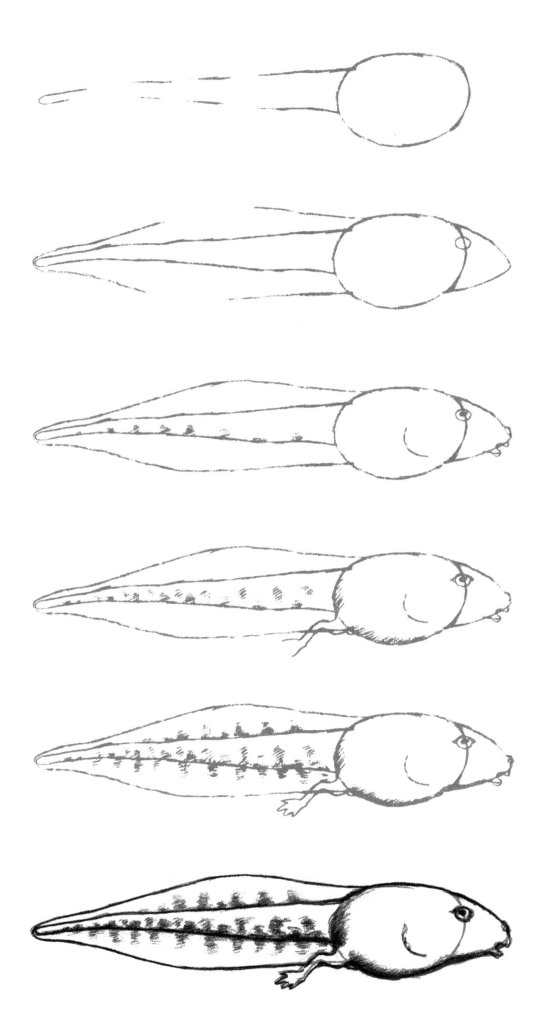

FROG Tadpole

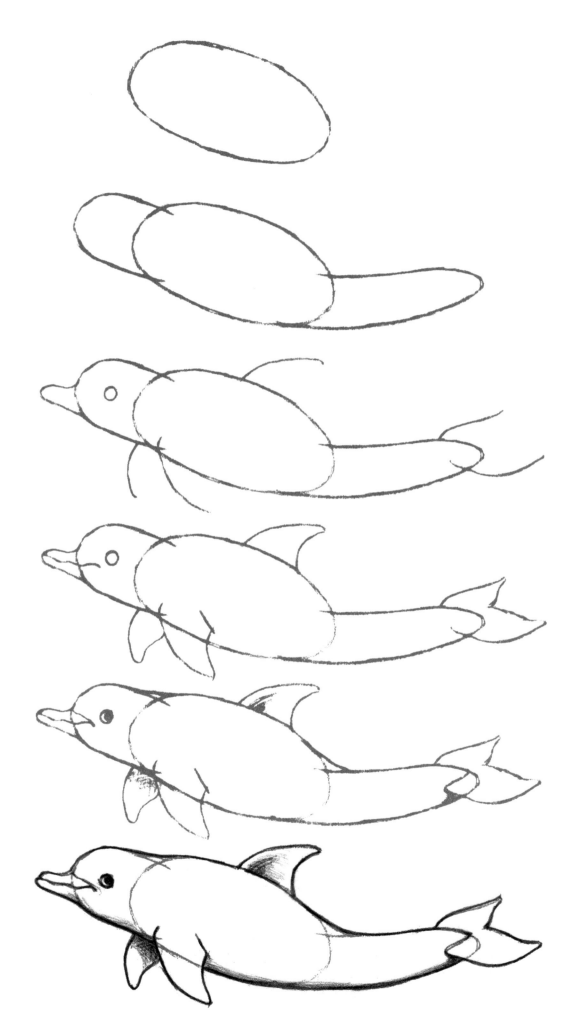

DOLPHIN Pup

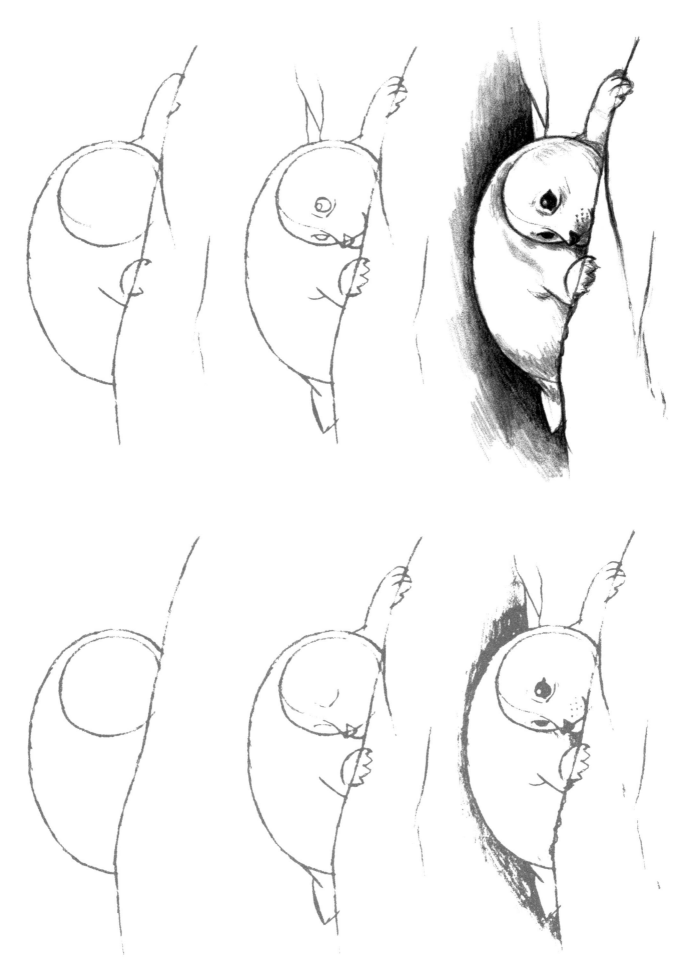

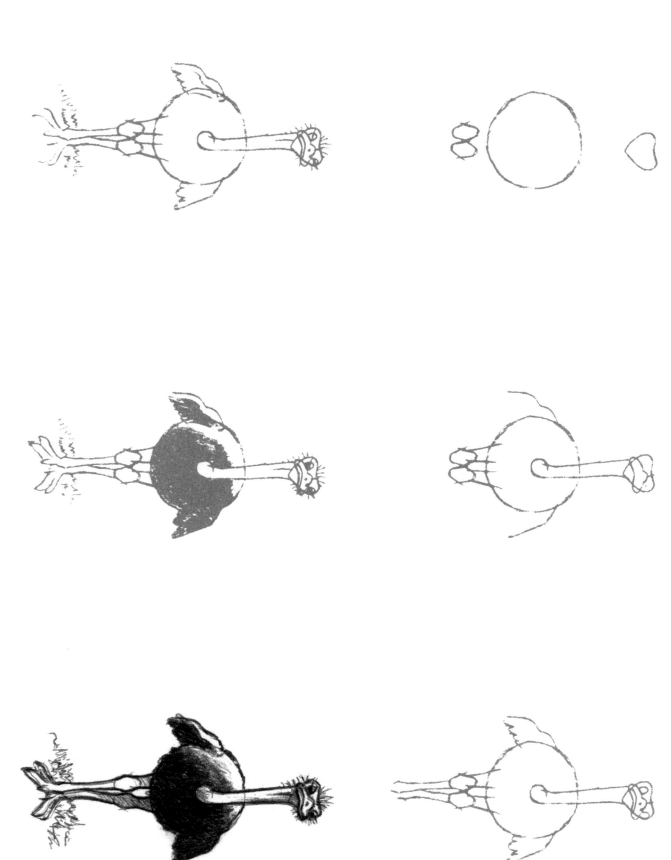

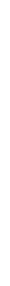 **OSTRICH** Chick

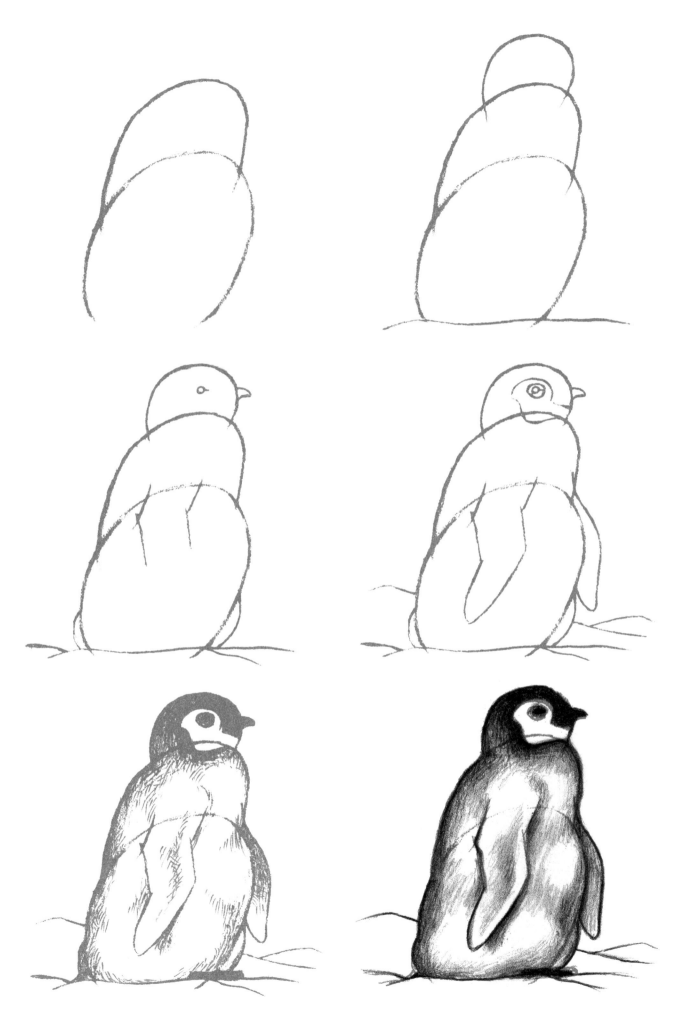

PENGUIN Chick

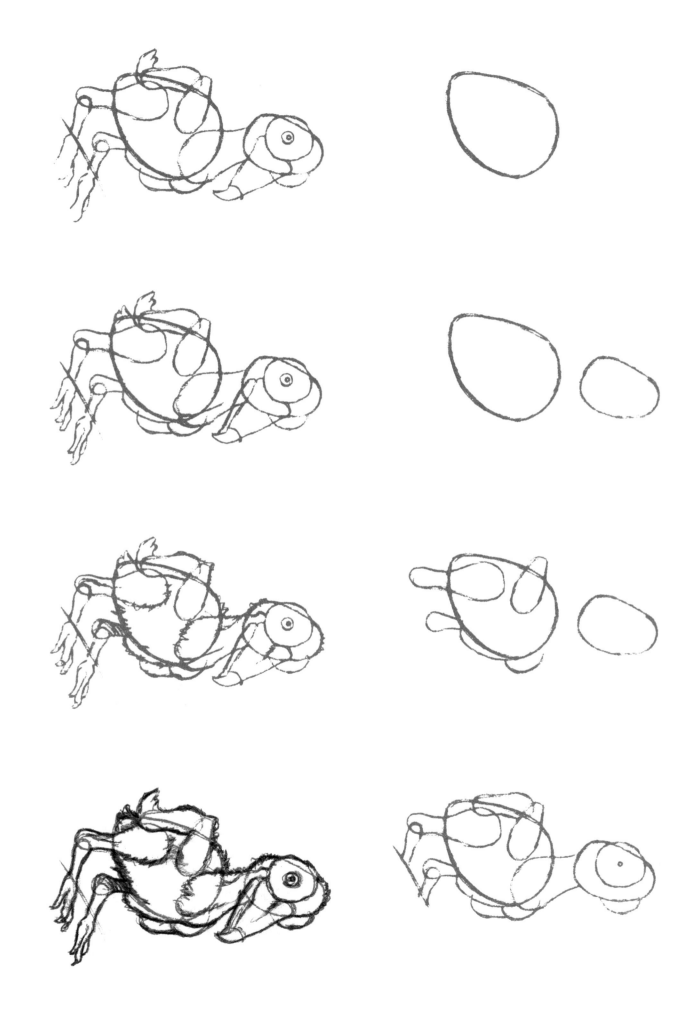

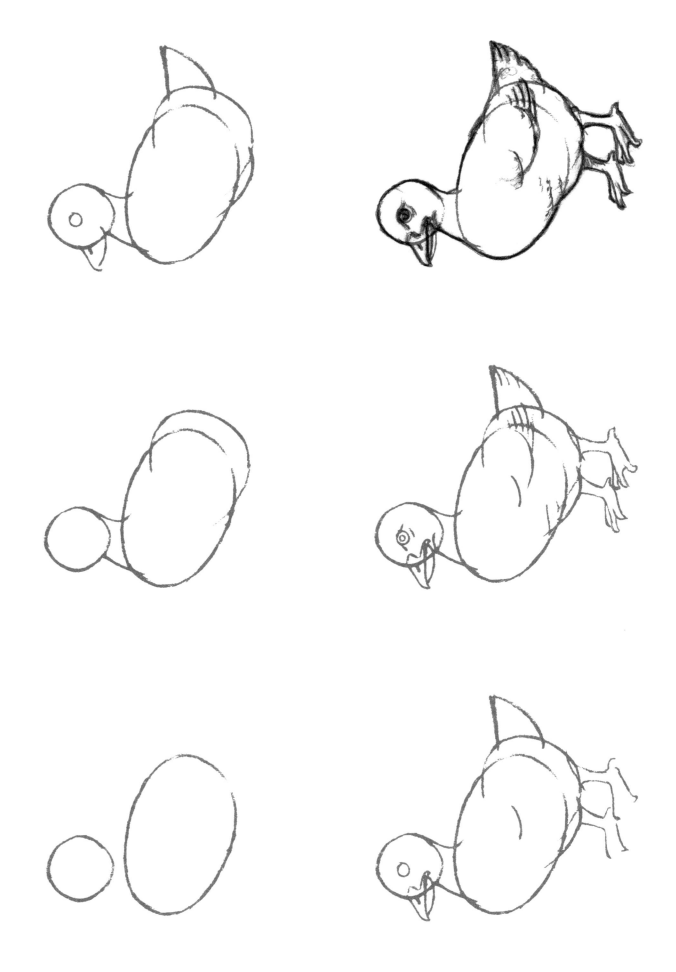

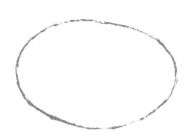
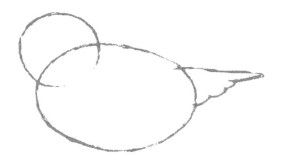
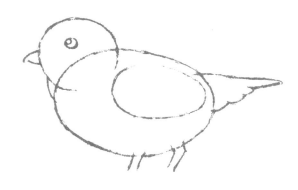
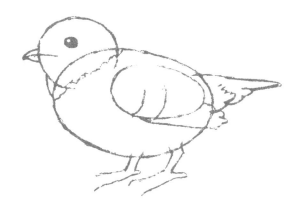
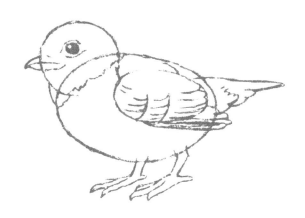
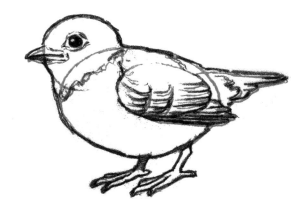

SPARROW Chick

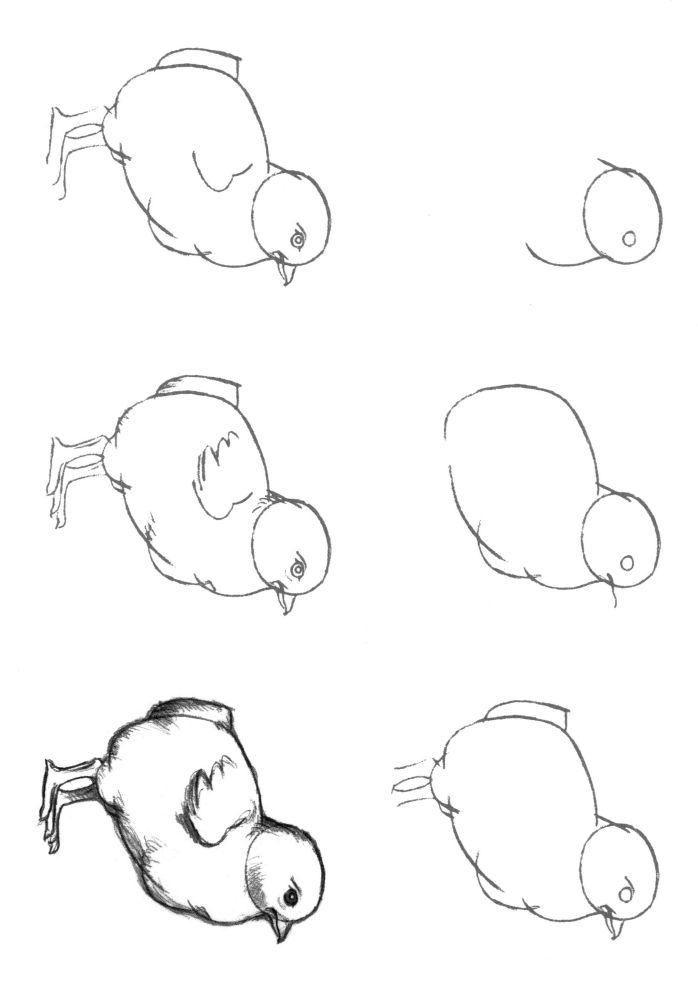

ABOUT LEE J. AMES

I've been married to Jocelyn for fifty-seven-plus years (either I'm lucky or I must have been doing something right). I have a son, Jonathan (his wife's name is Cynthia), and a daughter, Alison (her husband is Marty). I have three grand-kids named Mark, Lauren, and Hilary Novacek, and a grandson-in-law, Christian. And I dare not omit our two magnificent hybrid canines, Missy and Rosie. All of the above are the makings of my lovely adventure!

Me? At eighteen I got my first job, at the Walt Disney Studios. Counting travel time across country, that job lasted three months. I've been cashing in on the glory ever since! I've worked in animation, advertising, comic books, teaching, and illustrating books (about 150). I'm the author of more than thirty-five books (mostly the Draw 50 series). All have helped me happily avoid facing reality. We now live in the paradise of Southern California, but I still maintain membership in the Berndt Toast Gang, New York's chapter of the National Cartoonists Society.

DRAW 50 FOR HOURS OF FUN!

Using Lee J. Ames's proven, step-by-step method of drawing instruction, you can easily learn to draw animals, monsters, airplanes, cars, sharks, buildings, dinosaurs, famous cartoons, and so much more! Millions of people have learned to draw by using the award-winning "Draw 50" technique. Now you can too!

COLLECT THE ENTIRE DRAW 50 SERIES!

The Draw 50 Series books are available from your local bookstore. You may also order direct (make a copy of this form to order). Titles are paperback, unless otherwise indicated.

ISBN	TITLE	PRICE	QTY	TOTAL
23629-8	Airplanes, Aircraft, and Spacecraft	$8.95/$13.95 Can	× _____	= _____
49145-X	Aliens	$8.95/$13.95 Can	× _____	= _____
19519-2	Animals	$8.95/$13.95 Can	× _____	= _____
90544-X	Animal 'Toons	$8.95/$13.95 Can	× _____	= _____
24638-2	Athletes	$8.95/$13.95 Can	× _____	= _____
26767-3	Beasties and Yugglies and Turnover Uglies and Things That Go Bump in the Night	$8.95/$13.95 Can	× _____	= _____
47163-7	Birds	$8.95/$13.95 Can	× _____	= _____
47006-1	Birds (hardcover)	$13.95/$18.95 Can	× _____	= _____
23630-1	Boats, Ships, Trucks, and Trains	$8.95/$13.95 Can	× _____	= _____
41777-2	Buildings and Other Structures	$8.95/$13.95 Can	× _____	= _____
24639-0	Cars, Trucks, and Motorcycles	$8.95/$13.95 Can	× _____	= _____
24640-4	Cats	$8.95/$13.95 Can	× _____	= _____
42449-3	Creepy Crawlies	$8.95/$13.95 Can	× _____	= _____
19520-6	Dinosaurs and Other Prehistoric Animals	$8.95/$13.95 Can	× _____	= _____
23431-7	Dogs	$8.95/$13.95 Can	× _____	= _____
46985-3	Endangered Animals	$8.95/$13.95 Can	× _____	= _____
19521-4	Famous Cartoons	$8.95/$13.95 Can	× _____	= _____
23432-5	Famous Faces	$8.95/$13.95 Can	× _____	= _____
47150-5	Flowers, Trees, and Other Plants	$8.95/$13.95 Can	× _____	= _____
26770-3	Holiday Decorations	$8.95/$13.95 Can	× _____	= _____
17642-2	Horses	$8.95/$13.95 Can	× _____	= _____
17639-2	Monsters	$8.95/$13.95 Can	× _____	= _____
41194-4	People	$8.95/$13.95 Can	× _____	= _____
47162-9	People of the Bible	$8.95/$13.95 Can	× _____	= _____
47005-3	People of the Bible (hardcover)	$13.95/$19.95 Can	× _____	= _____
26768-1	Sharks, Whales, and Other Sea Creatures	$8.95/$13.95 Can	× _____	= _____
14154-8	Vehicles	$8.95/$13.95 Can	× _____	= _____
	Shipping and handling	**(add $2.50 per order)** × _____		= _____
		TOTAL		_____

Please send me the title(s) I have indicated above. I am enclosing $_____.

Send check or money order in U.S. funds only (no C.O.D.s or cash, please). Make check payable to Random House, Inc. Allow 4–6 weeks for delivery. Prices and availability subject to change without notice.

Name: _____

Address: _____ Apt. #_____

City: _____ State: _____ Zip: _____

Send completed coupon and payment to:
Random House, Inc.
Customer Service
400 Hahn Rd.
Westminster, MD 21157

BROADWAY